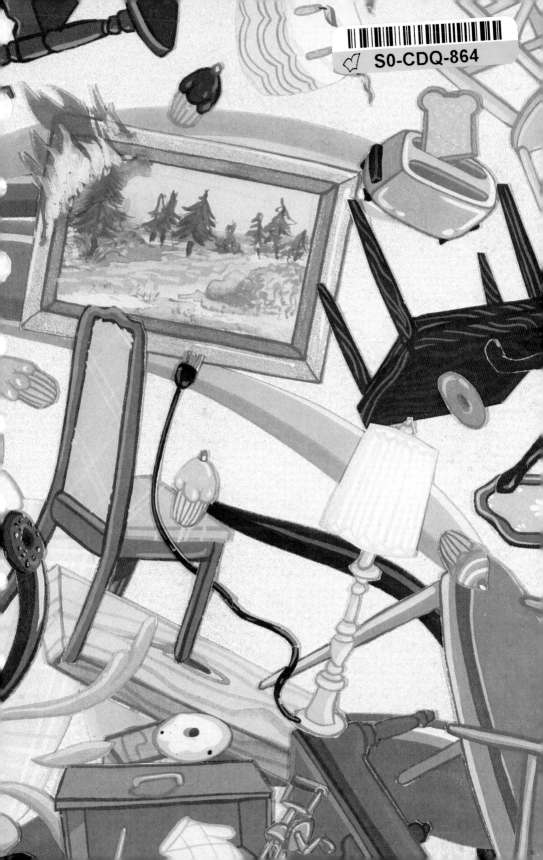

ExSt Exquisite Editorial Corps

Lynne DeSilva-Johnson
Benjamin Wiessner
D.A. Wright

EXIT STRATA : PRINT! VOLUME no. 2
was produced and designed in BROOKLYN NEW YORK
Copyright ©2012
ISBN: 978-0-9855180-2-8

www.exitstrata.com

The editors would like to thank
all our wonderful contributors
Daniel Stone, Nancy Taussig, William Considine
our supporters, friends, and family
for making this issue possible

this issue features Collaborative Content
from the Exit Strata CoCo Salon (August 2012)
held @ SpaceSpace : Queens NY

Ada Athorp
William Considine
Allison Malinsky
Matt Nelson
Konstantin Prishep
Lancelot Runge

Amber Snider
Ananda Kahn
Frank Ortega
John Munshour
Carey Maxon
Sarah Meyer

{cover art: Carey Maxon, *Stars and Minions,* 2012, 18 x 24 inches, oil on linen}

eXit strata

EX TRATA

chorós tis Kassándras

A WORK IN THREE ACTS

CHARACTERS OF THE PLAY ON THE STAGE

MODERN WOMAN
GREEK WOMAN
THE ARCHITECTS
WALTER
EMILY
NURSE
MODERNIST MYTH
HERMAN (CAT)
ORACLE
RAJESH
ALICIA
FRANCIS DRAKE
GLITTER HOODLUM
SOLON
SHIP OWNER
THE HANGED MAN
LIONFISH
HERMAN (HUMAN)
HEGEL
THE SEVENTH SON OF A SEVENTH SON
FERENC
ISTVAN
DAGOMIR
KANGAROO

Ancient Greece is the scene,
centuries before the Classic Age,
emerging from myth into glimpses of memory,
a golden fleece and then this:

Olive groves on hills, sheep roaming
mountains like clouds. Athens, source
of the Western world, is a crowded town.
Above is a rock fortress, the Acropolis.
These people rode the bright sea.
They caught wind in one sail
or rowed together in a rhythm of whole bodies.
They clung to coastlines and harbors, then
darted over wide sea to Egypt, Libya, Sicily.

But an ordinary rainstorm passing
like a veil across the sea
onto men in open boats was terror,
sometimes shipwreck and drowning.
Our tale tonight is a few facts
emerging out of mythic thinking.
So many people have tried to penetrate
the misted, dreamy sources of memory.
The darkest parts will always be hidden.

ACT I

Towards the Design (*Allegretti*)
You are Now Disappearing (*Shippy*)
In This Way (*Cappello*)
The Proxy (*Russell*)
The Modernist Myth (*Owen*)
Interlude : Radio Wave/Biophany (*Swann*)
Twenty-Eight : Part I (*Lang*)
Francis Drake Boulevard (*Sloboda*)

ACT II

Periwinkle Project (*Allegretti*)
Letter (*Beecher*)
Confirmed Report of a Single Lionfish (*Bagoo*)
Waiting for Azaan (*Marie*)
She's (*L'Homme*)
Interlude : The Hanged Man (*Swann*)
Twenty-Eight : Part II (*Lang*)
Eating My Words (*Tricarico*)
Francis Drake Boulevard (*Sloboda*)

ACT III

The Seventh Son (*Allegretti*)
In Green Begin (*Wat*)
Pink Slip (*Fleischer*)
Europa (*Gallo*)
Interlude : Ego-Doll Dance (*Swann*)
Twenty-Eight : Part III (*Lang*)
A Life in Passing (*Aaron*)
Francis Drake Boulevard (*Sloboda*)

Act I

MODERN WOMAN:

> Athena! Goddess with a shield, sheltering
> life in cities! We've seen too much war!
> Long, sporadic, harassing campaigns, raids,
> pirates scrambling from their boats ashore,
> rushing shouting death into workaday cities,
> burnt crops, burnt homes, murder,
> war between neighboring towns—cousins
> clashing, bleeding in the cruel curse of iron.

GREEK WOMAN:

> Megara and now-famous Athens are towns
> close by one another, on the same coast.
> Midway between them is Eleusis, the shrine
> of the earth goddess, the core of the world.
> They fight for many years over lands
> between them to feed their bustling towns.

TOWARDS the DESIGN and CONSTRUCTION
of a HOUSE in the SHAPE of WATER

> Architecture in general is frozen music.
> Friedrich von Schelling (1775 – 1854)

> O wizard of changes, water, water, water.
> Robin Williamson (1943 –)

Vitruvius doesn't address the subject in *The Ten Books on Architecture*.
Neither does Le Corbusier in *Towards a New Architecture*. Neither does Rem
Koolhaas in *S, M, L, XL*.

In *From Bauhaus to Our House*, Tom Wolfe considers buildings designed by Mies
van der Rohe, Eero Saarinen, and Philip Johnson, but not this.

Architects have realized structures in the shapes of:

- a basket (headquarters of The Longaberger Company, a basket
 manufacturer in Newark, Ohio. Architect: unknown);
- a conch shell (private home on Isla Mujeres, Mexico. Architect:
 Octavio Ocampo);
- a teapot (gas station in Zillah, Washington. Architect: John
 Ainsworth).

None to date—not Garnier, not Gaudi, not Gehry—has brought into three dimensions a dwelling in the shape of the shapeless.

Career Counsel

Become that architect.

Step 1. Enroll in a distinguished school of architecture, such as California Polytechnic State University or Cooper Union, and earn a bachelor's degree.

Steps 2 and 3. To hold yourself out as an architect, you need a state license. Therefore, you additionally must:

- complete an internship with a firm;
- pass all seven divisions of the Architect Registration Examination®.

Think about an office by the ocean or at least a lake. For inspiration's sake.

Recognize that you'll have to fund the construction, since no one will commission it.

Know that your creation will attract notice and invite interpretation.

"Mediterranean," the Continental among us said.
"Red,"
held the Cairo-bred real estate broker.
The architect, Chicago born and raised, shook his head.
"Lake Michigan."

YOU ARE NOW DISAPPEARING MISS E.

Late night. A basement den—small couch, coffee table, and flat screen. Dressed in pajamas, WALTER and EMILY are watching TV.

Emily: I'm ready to hit the hay. Sleep?

Walt: Sleep? Hell, yes.

WALT *uses the remote to turn off the TV. They rise, stretch and look up. A two-pronged ladder descends. He begins to climb, closely followed by EMILY. They slowly ascend. When he's halfway up the ladder the TV starts to glow.*

TV Voice: Don't turn. Don't look back. (*Long pause. WALT turns and looks back. EMILY disappears. The ladder becomes unsteady. He clings to the pitching ladder, trying to watch the TV. EMILY'S face appears on the screen.*)

Emily: A poem: "Le déjeuner en fourrure."

> We rode out the hurricane
> At a deadbeat in Vermilion Parish.
> She signed a waiver to assuage
> The motelier from giving a rat's ass.
> She moved a roll-up from her ear
> To her mouth to my mouth. "Zombie?"
> "Scout's honor." As we screwed
> Her blue toenail played my balls
> Like the black keys. When I was close
> I bailed out and sank, passing
> My tongue over her nipples belly
> Whispering *pudenda, mon amour*
> And we cracked-up as she came
> Like milk from a stone and after
> She pinned me and *swinged me again*
> As I chewed over an almond
> Backswimmer crossing the popcorn
> Ceiling, hauling our souls
> To its arkette, *two by two.* After,
> We microwaved mixtos and cartooned.
> A turtle desired a pet dog.
> His parents were dubious. "My mother
> Yanked the shell off mine," she said.

The wooden planks nailed across
The windows brayed. The barometer fell.
Easy to imagine we were
In a frigate, below decks, shipping
To the fringes—the antipodes,
Europa. "She swore it was an oops.
She was just looking for its pearl."
I purred the word. "From the Latin,"
She said. "*Pundendus*: to be ashamed."

Long pause. We hear the sound of wind, waves, electric guitar and birds.

Walt: Together in shame!

WALT *starts to rock and roll until, frightened, he ascends and disappears.*

Emily: Erato carried his lyre to heaven and placed it among the stars. I'm still here.

Lights dim, EMILY shines.

{CURTAIN}

Perpetual collages of things gathered up and falling. It is not present, nor are arms
to collect awake or sleeping, birdchirp dawn reseeding. The purr of rain. Arterial.
His hands of calloused metal.

Moving. What is motion? Small sounds.

Fragile things. Fog so thick the bridge
is swallowed solid. Covered. Crashed
ashore things. Cannot remember the floor
I navigated. Forging fire four am, no lights.
Livid. The way anger made his face
sideways and vacant. Heavier than old hope.
Memorized. Remember? This is the way to
knead the bread. The drops of rice to water.
Remember the prayers, mantras.

Further. Streetlight curfew.
Concrete silhouettes closer and more
confused. Broken up and capturing light.
That snake was missing half a face.
Remember? Skin peeled back exposed
where an eye should be,

Is. To see, see? Or, to go.

In this WAY I REMEMBER, and ALSO I

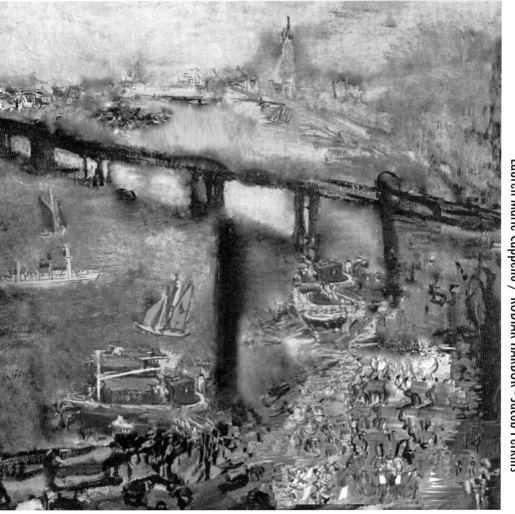

Lauren Marie Cappello / KODIAK HARBOR - Jacob Perkins

The PROXY

He sends me a photograph. CHEMOTHERAPY.

A Ziploc baggie: OBSERVE SAFETY PRECAUTIONS FOR
HANDLING AND ADMINISTRATION. Matted against a wrinkled white
sheet, black text in a perfect yellow square.

This is a beautiful photo. I'm going to save it, it is a great one.

I love it. I save it.

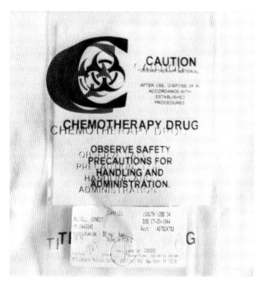

This is how Western medicine works: a Vince Vaughn movie at 3 o'clock,
curled into a chair, drooling on myself while my back muscles spasm. They whisk
him away, a tomb on wheels, sheets soaked with sweat, a weekend's worth of
hospitality. While he is gone I feel relieved. *It's out of my hands now.* That night
at home I take sleeping pills and stay awake. I close my eyes; the lids bounce back
immediately, rolling balls inside gummy and glued to the ceiling, time crippled,
limping on.

Nighttime doesn't come. I watch the shadows travel across the walls—charcoal
handprints, streaks directing dream traffic toward an ocean of blankets. I put
my arms out, floating on my back. At dawn I begin to spin for the first time. *The
water's cold, I want to get out. I can't feel my legs.*

~~~

At NYU Langone a paramedic pauses outside, resting hands on a neon orange
gurney, "Oh my god, I made it out of there alive." She notices me next to her,
shivering in November's kiss, bloody eyes, bruised by morning light.

Apologetically: "Sorry."

9

Inside the hallway—near Elevator K—there is a woman leaning against the brick wall, Institutional Gray. She has white hair, teased into a partial bouffant, swept forward over her forehead, black glasses tripping over the sharp tip of her nose. She is eating a bag of Fritos. Each corn curl slips between two thin lines of flesh rolled with purple, clay scored with 1936, then 1952, then 1992, then 2008. Somewhere above her black Reeboks swings a Chanel bag, slung over a scuffed jacket cuff, lined with fur, a neatly manicured hand emerging from a Méret Oppenheim tea cup.

<div align="center">~~~</div>

On the way up a cab had pulled over with his off-duty light on. The window rolled down: a stranger.

*Can you take us to the hospital, please. It's on 32nd Street and 1st.*

I get into the front seat so they can't see me; two blocks up the driver notices my hiccuping through tears, snot pooling above my upper lip.

Alarmed: "Is something wrong?"

I console him: *Everything is going to be alright. Everything is going to be just fine.* A whole wheat blueberry muffin from Veselka. A mocha that fails to do the trick.

"Don't get upset but...what you just drank was actually just a decaf."

Nurse shoes shuffle behind curtains, constantly drawn. Checkered rainbow trim.

<div align="center">~~~</div>

In December, instead of holiday ornaments, I help him pin a sign up, scrawled on budget-conscious brown paper towel sourced from the WOMEN's room. Like a woman, I do my part: *DO NOT ENTER FROM THIS SIDE.*

I do not get angry anymore, I get quiet. *I shut it all up tight.*

"Good," He says, stumbling through steroids prescribed to reduce swelling. "Shut it up tight."

Later: "I love you."

At dinner, rolled in on a cart, incubated by heavy forest green plastic, convex: "I must have done something wrong to have you two turn out like you did."

Outside it is the isle of Manhattan, a balmy sixty-five degrees, the leaves on trees lining 2nd Avenue molting and balding, golden and confused at the surprise of Spring on what was supposed to be written as another sadistic Winter afternoon.

<div align="right">Legacy Russell</div>

## The MODERNIST MYTH and I

We go for a walk
and he whispers sweet sweet
in my ear like a mourning dove
in a car stereo system
the grass is so green
and has eyes that look up at us
on the brink of tears

How do you do Marxism?
I ask the Modernist Myth
and He coos and grunts
How do you do Lacanian analysis?
What is a boot?
How do you do post-traumatic structuralism?

And I feel so special
with the Modernist Myth
His purrs and stutters meant for my ears
my whole body feels like a yawn
a contagious yawn I caught from the Modernist Myth
that I can pass on at will to everyone else
a yawn like a matchflame
and I am smarter and stronger than ever before
and the yawn lights my cigarette
and the Modernist Myth brings me a glass of good bourbon
I can't afford
He acts sometimes like money's no object
and sometimes like money's no subject
I learn to evade bills as long as possible
the bourbon feels like liquid gold going through me
and I'll find a way to pay for it anyway
because I'm young and healthy and white

Modernist Myth, how do you do Maimonides?
and how do you do Ecclesiastes?
What is an eye?
And the Modernist Myth, he goes on
meows and roars
and I just nod my head
I am alone and magical
when I'm with you Modernist Myth
then the ocean falls into itself again
and I can't afford another drink in this city
so I go home and lie down
with the Modernist Myth beside me like my cat, Herman
and I write down the sounds the Modernist Myth makes
through the night
which I'll later type up and revise and read to you

*for Pareesa Pourian*

Dan Owen

12

## RADIOWAVE DANCE

One person turns the knob on the radio rapidly
the others dance to each note of fuzz and sound sensitively

the deep understanding that everything changes
pervades the mountain.

This can also serve as an invocation for benevolent extraterrestrials.

Turn off the radio and begin:

## THE BIOPHANY BODY ORACLE

The animals on the mountain have divided up the acoustic spectrum
mapping the land in waves of pitch.

Move yourself around the aural niches in
the soundscape of the mountain.

We will observe your movements
and discern the future
and
solutions for sustaining human life on Earth
giving all our future babies
psychic bliss
treehouses
and the ability to converse with animals.

Eliza Swann

Rajesh heads to the break room for his fifth cup of coffee, trying not to feel self-conscious about his numerous trips past reception and the waves of scrutiny wafting from the front desk. He has noticed recently a distressing correlation between the amount of coffee he drinks and the amount he cares about his job—a relationship so unnerving that his only recourse is to caffeinate his concerns into submission. Otherwise, certain questions pester him: what it means that he has to drug himself into doing his job, for example. Or why he feels lost and uncertain when he should be securing his life into a neat package with a bow.

To silence such questions, bubbling and murky, Rajesh seeks the jolt of excess. It is not enough to be mildly abuzz, antennae alert, mind clear. Better to be vibrating with determination, charged like a defibrillator. He takes a delicate first sip and cradles the mug between his hands to prevent any sloshing on the walk back to his desk.

Before the fifth cup, he had been slumped at his desk, slouched so low that someone walking by wouldn't know the chair was inhabited. He'd drifted to websites without knowing why, his morning ritual of Web wandering, ignoring the focus group reports on his desk, the PowerPoint presentations in need of doctoring. The company logo blossomed across his monitor, reminding him that both he and his computer should not be idle. HKCP: the letters set in block typeface, the partners' initials from the Philadelphia-based marketing firm where he worked as an Associate, forming a neat square. The logo sometimes makes its way into his dreams, flowering in the background, appearing on the foreheads of his loved ones like a tattoo. It spoke, he thought, hurriedly activating his mouse, to the power of branding.

Today, in the pre-jolt lull of the morning, he'd ventured to Hermes.com. Alicia had pointed out a watch of theirs over the weekend in one of her glossy fashion magazines. It was a five-thousand-dollar vision with an orange crocodile strap and glinting gold face ("Wow," he'd said, studying it over her shoulder. "Is that like Hermes the Greek god?" "*Hermès*," she'd corrected, frowning. "Don't you know them? They're, like, amazing").

Rajesh had clicked through Hermès collection of "Timepieces" (not "Watches," he noted; high-end retail preferred high-powered words) and wondered who could afford this stuff—who these people were, what jobs they had. Market demographics at Hermès probably involved some of his peer group. He imagined his friends from Wharton coming home for the holidays with flashy chronographs on their wrists. He imagined Sanjay's parents raising their eyes skeptically, the way his would, worried that their strange American son was squandering his money. Andrew's parents would slap him on the back, congratulating him on doing so well.

He had perused his friends' online bios next, a ritualistic stop for him during his morning warm-up. He examined the headshots, the quietly impressive profiles. The people he played beer pong and went bar-hopping with ("pub-crawling," Alicia would say) suddenly looked dignified, accomplished, when captured in black and white. "Ms. Chen specializes in corporate transactions and mergers for international conglomerates," he read. "Mr. Flytt's expertise is in corporate mediation." *Mr. Flytt's expertise is in puking in my bathroom*, he thought.

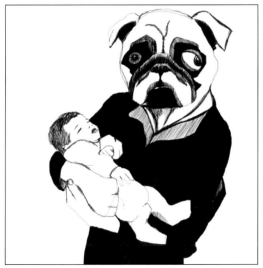

The bios are a mash of corporate speak with words like cumulus clouds, seemingly full yet consisting of nothing more than vaporous mist. Rajesh re-reads these descriptions each morning, trying to glean meaning from them—as though if he caught them in just the right moment, they might yield clarity. But pressed for details, he and his friends would be unable to say what it is they do. There are buzz words: "Grace? She does corporate law at Wescott." Or, "Oh, Sanjay—he's in finance at Citibank." But they can only offer adjectives (*international*, *transactional*, *commercial*), a sprinkling of nouns (*technology*, *firm*, *finance*). There are few verbs. A dearth of prepositions. No specifics on what is being done. With whom, where, to what end.

Flying high after his fifth cup of the Starbucks blend the office manager buys in bulk, such uncertainties dissipate. He sits up straighter where the air is clearer. He feels ready to tackle the PowerPoint slides, giddy with the thought of getting through the stack before lunch. He sends emails with "FYI" in the subject line. He fires through his inbox, makes lists of tasks, and staples things briskly, enjoying the mechanistic bite of metal into paper.

He speaks pleasantly with his supervisor, feeling no pangs of anxiety. Wouldn't it be a good idea, he ventures, to go to DC to check on their client? His supervisor looks up from his keyboard and smiles.

By the end of that fifth cup, Rajesh feels nearly weightless. This is his zone: predatory, prowling, efficient. He remembers an article from last week's *Wired* that he'd flagged for the Casey project. He wonders why he'd been hesitant to forward it to his team. Next time, he vows, he will send it sooner. Next time, he will keep his doubts at bay.

"Raj, can you believe it?"

He steps into the foyer, setting his briefcase against the wall. Alicia is in the kitchen, spoon poised in mid-air. A brown UPS box is on the counter, the tape a gummy tangle.

"So you, um, actually like this stuff?" he asks after tasting a bit. His tongue has retreated instinctively into his mouth, a turtle going back into its shell.

"Are you kidding? Every Aussie loves this." She waves the jar of Vegemite enthusiastically. "I don't know if you guys have anything quite like it here. It's like, I dunno, like Wonder Bread, maybe."

Alicia is still in her uniform of black yoga pants and hot pink tank top. As she passes him in the kitchen's tight space, he gets a whiff of something musty. Not sweat, exactly, but something synthetic, like foam or rubber. Must be her mat, he thinks.

They had ordered the Vegemite online a week ago. He had come home to find her staring out the window, wrapped in a sweater. "Raj, I thought winter was supposed to be festive here," she said morosely. "I thought there'd be snow."

It had taken him some time to recognize her bad moods because they were so benign—passing clouds (as opposed to Grace, who used to darken the room, rage and thunder). There she was with her rosy glow, wanting nothing more than to inhabit a snow globe of holiday cheer. It was adorable. But then he noticed the look in her eyes—a flat, vacant gaze she reserved for

objects. It made him think of the Australian plains, a barren landscape of flat dunes, the strange hippopotamus of her continent, adrift at sea. ("Everyone always asks me about Sydney," she'd once told him, irritated.) "Snow will come. In the meantime, what would make you feel better? Maybe some stuff from home?"

It was a genius move. He'd found the website and all of her enthusiasm had returned in a flood. "Tim Tams? Oh, oh, and Violet Crumble! Of all things!" She was laughing now. "My goodness, they have everything. Raj, look at this. They have Polly Waffles!" Scrolling down, their faces bathed in the blue light of the monitor, Rajesh marveled at the experience—triumphant but novel—of having a girlfriend he could soothe. He wondered if it was because she came from a place that trafficked in goods with fairy tale names. Maybe it brightened your outlook, he thought, surveying the colorful packaging. Maybe it made things a little less somber.

He thinks of the target market for the products making her mouth twist into a nostalgic smile. He imagines an ad campaign, surfers in wetsuits pausing in their beachside frolicking to tear open a package.

"You have dinner with Herman tonight, no?" she says, rummaging through the fridge for the bread.

"That I do. He's got a new job, apparently."

He imagines Andrew and Sanjay and Grace in a focus group, seated around a table watching the ad. *Polly Waffles?* Just the name would cause them to shift uncomfortably. American consumers preferred consonants, firm and reassuring: Snickers, M&Ms, Skittles. They did not respond to flighty evanescence, to names with lofty sounds. "Seems kind of pansy," Grace would say, and the guys would concur.

Alicia pivots gracefully towards the toaster. She waves a slice of bread his way. "Toast?"

"No thanks," he says. The aftertaste of the Vegemite lingers. It had tasted like beef broth, except cool and gelatinous. "Have to save room for steak."

"More for me then," Alicia says with a wink.

In the commercial, too, there would be a wink directed at the camera. *Young, fit people eat these foods. They are carefree and will live forever.* It is only when Alicia takes a bite, her eyes closing as she gets transported home, that Rajesh realizes he has unconsciously been imagining her in the ad—a surfer with blond, blond hair.

"Give my love to Herman," she says affectionately when he grabs the keys. "And tell him congrats."

...

("28" continues on pg. 39)

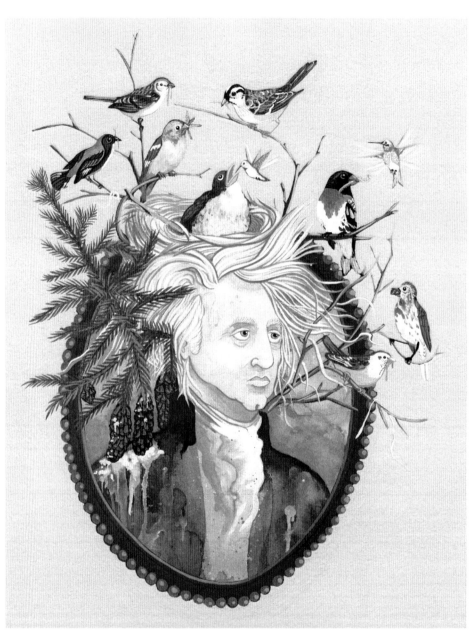

**Sir FRANCIS DRAKE BLVD. (III)**

We are the unintentional kings of lost puppies. Unbeknownst to the snows we too are drifting everywhere, marked in our travels by the last life of the deer. On shoulder side, stalled at the speed of late night with feint neon light on broken antlers where the law falls fully naked on the buck, will you not believe me that we are the true criminal species of the known universe? Cold in Canadian tuxedos, we traded our employment for passage of a deeper time. A joke. A koan. Like I'm surfing thru the visual display of a greater mind, the luminosity of virgin highways beneath the soup of stars whispers telepathically a treatise of feelings. It brands some eyes with tenderness and loss. In the subtly shifting shadows from the moon on aspen groves, the outline of everything is so enormously soft. To think of stepping through these blossoming doors of night brings spiritual ascendency before collapse. Thus, with disabling gratitude we seek brightly colored daydreams upon the regions most likely roads on which to die, the waves of colors filtering a different sense, like herons paused along the water's edge, accelerating chemicals of the watchers when they fly.

You
the
glitter
hoodlum
rocket
bicycle
to
the sixties

follow
the cult
towards
a pictoral door
+
hurt ochre stars

shaking
beneath
the
nameless
kiss
amid
their
morphine
stomach
trembles

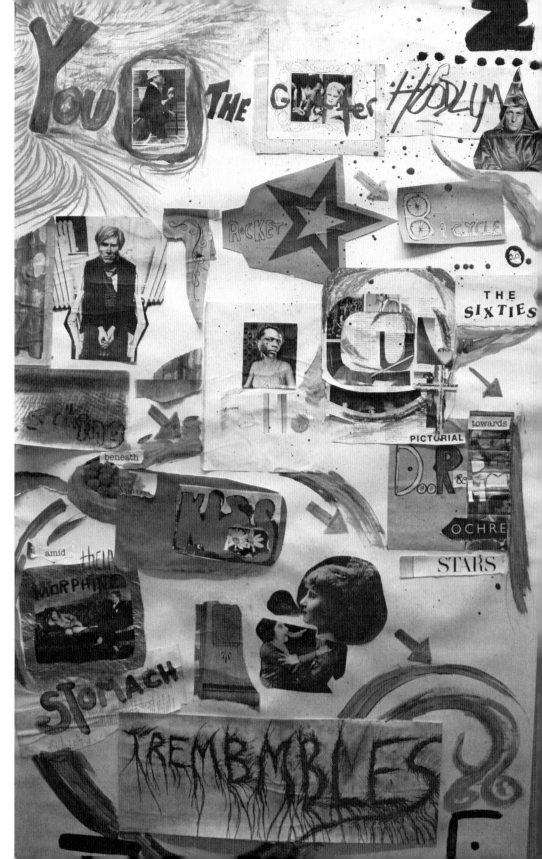

SOLON:

    Death is that way, so I'll go this way.

    Or is it,
      Death is that way, we all must follow.

SHIP OWNER:

    Are you feeling well?

SOLON:

I'm well enough for a man
without wisdom,
but too ill to hear truth when men talk.

# ACT II

## The PERIWINKLE PROJECT

1. Periwinkle is a Crayola® color.

2. *Periwinkle* is a 1917 film starring Mary Miles Minter.

3. Periwinkle is a sea snail, taxonomy *Littorinidae*.

> This is concerned with no. 3.

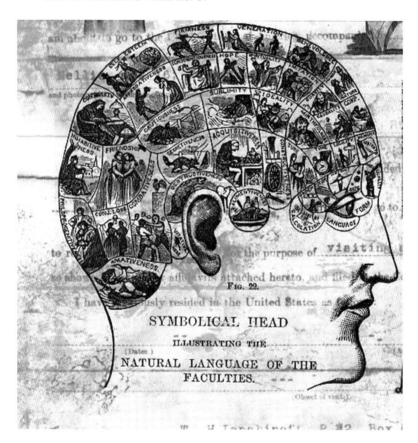

The common periwinkle (*Littorina littorea*) lives along
North Atlantic shores. It is not periwinkle (see no. 1).

The blue periwinkle (*Nodilittorina unifasciata*) calls home
the waters off the coasts of Australia and New Zealand. As
a blue periwinkle, it is a blue periwinkle—with a touch of gray
(apologies to the Grateful Dead).

The rough periwinkle (*Littorina saxatilis*) is a littoral jetsetter.
It loves Chesapeake Bay, the Barents Sea and the Strait of Gibraltar.
This periwinkle, like the first periwinkle, is not periwinkle.

Your assignment, should you choose to accept it, is to travel to one of the destinations noted above and for 30 days live in the shallows as a periwinkle.

When you return home, and after you have reacquainted yourself with your terrestrial circumstances and with cooked food, write for submission to *The New York Times Magazine* a 5,000-word article about life inside your shell.

Dear Editors,

This won't be the first time I've submitted to a literary magazine. The first time, I plagiarized a poem. It was a Galway Kinnell poem—a wonderful one with frogs ribbiting in it. It was high school. My best friend at the time confronted me about it. We haven't brought it up again. That was also the first time someone called me out. The second time I plagiarized from a popular David Hockney book on the Renaissance. Also high school—AP Euro. I remember my teacher at the time asking me "do you imagine that I don't read," exchanging the essay that I had given him for a Xerox of the original published version. I haven't gotten caught since.

But as an artist I plagarize plenty. It's usually fine, but sometimes it haunts me. For my last show I used appropriated text taken from published self-help books. I changed it somewhat. Still I wonder, will anyone realize that a lot of it was only slightly altered? Gosh. Must everything I make be ridden with shame? Well, as Louise Bourgeois said, "it is that the past for some people has such a hold and such a beauty..." Editors, I know you were

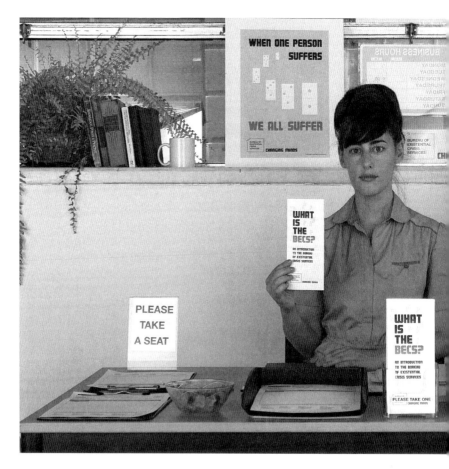

expecting a drawing. But I'm hoping there might be room in the next print edition for this little catharsis... Because wait—those aren't the only times I've plagiarized!

I remember there was another when I was much younger. I told my mother that I wrote a song called "Beautiful Beautiful Brown Eyes." It was a song I knew from a book of easy-to-play piano tunes. I don't remember how I released that lie into the world. My guess is boredom propelled it out of me as much as my desire to please. Often, the copious amounts of affection I received as an only child was not titillating enough. I wanted more! And so I sang the song to her:

> "Beautiful, beautiful brown eyes!
> Beautiful beautiful brown-ay-es!
> Beautiful, beautiful brown eyes!
> I'll never love blue eyes again!"

What a stupid song. I think it's some sort of traditional British ditty. Any child could have written it. Even as a child, I knew the odds of believability were

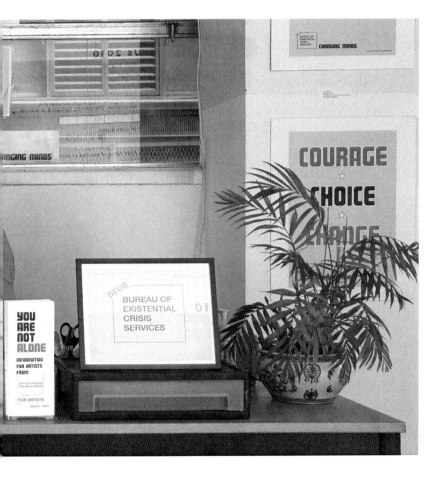

in favor of my lie, hinging my bet on the song's frivolity and triteness.

My mother did believe it. In fact, she was delighted by it. And I remember matching her delight with my own when she spoke about the song thereafter, her face blushed with pride-eyes twinkling. But naturally, the returns of that lie diminished, that initial satisfaction eroded by guilt and embarrassment every time she would mention "my" composition. The guilt: of knowing that I had engaged her in an unknowing game of make-believe. The embarrassment: that she continued to play despite my beginning to loose interest.

Eventually, her unknowing participation in the lie—her believing it and repeating it with me—became a smudgy eraser over the truth, rubbing it out over and over until we poked a hole in it, an empty space where my untrue blemish was replaced not with some redeeming confession but with a small puff of hot air... a blip in the white noise of time passing.

That lie was like a bubble. It was optimistic and delicate and empty. It floated into the timeline of my accomplishments, hovering next to those more grounded in reality: school plays. A-minuses. The best drawings of all the other campers. And then, further down the line, more exercises in plagarism:

I told my sixth grade class that I composed a jazz song and played it to everyone during Music period.

I told my best friend that I had made up a joke that I heard Gilda Radner do.

I told my first boyfriend in college that I had sewn the dress I was wearing.

I made dozens of copies of Joan Mitchell paintings (but those were unsuccessful so do they really count?).

I've stolen tons of phrases from other artists' artist statements.

I pretended a recipe for fruit salad with minted syrup was something I made up but really it was Julia Child's.

I'm spending money that I don't have on a fancy Freudian shrink. We talk about my mother and I remember that lie in her office often. I remember sitting at the dining room table, her smiling, laughing about that song—me letting her compliments slide off of me like a bucket of water hitting a poncho, tongue touching dry drops of water from the inside.

But in my weekly 55-minute hours we have never talked about the repercussions of any of my plagiarisms. Really, I don't remember there being any. Not only do I not remember being punished, but I don't remember admitting to them either. In fact, I could call my mother right now, mention "Beautiful Beautiful Brown Eyes" and not be certain of what we are reminiscing.

My shrink assures me that, despite "getting away with a lot," I punish myself plenty, and it's true. In graduate school I made thin wooden sculptures that collapsed before there was even time for my peers to critique them. I turned down dating nice Jewish boys in favor of sadist after sadist. And there are more opaque types of punishments, too.

Take, for example, my recent sales job at which I have proven to be consistently mediocre. With so may forms to screw up, customers to displease, I am constantly avoiding the ringing of my phone—assuming behind it there is someone who's pissed. Today it rang and I was in my bedroom. I couldn't figure out who it was. I cowered to the floor to remove it from its charger but instead of standing up stood huddled over the chords crossing my toes, wondering if I'd fucked something up.

Anyway, I was thinking I could somehow work these experiences into whatever I do for the print issue. It's been on my mind. What do you think?

Best,
Amy Beecher

Amy Beecher

**CONFIRMED
REPORT of a SINGLE
LIONFISH SPOTTED AT
TOBAGO**

Not in my mind, but in the sea
Not in the sea, but in my body
Upon my spine, through lung and heart
Your spotted sails fly out my mouth

Inland, for decades, we sea-sleep
There is nothing poisonous here
But the rain has plans of breaking
Fragile aquarium walls.
Awake:
The thought of you.
Your deadly intent is beauty
So rich, the water comes whole
    A ghost, a swarm
Of inflamed tongue
O, all that was solid!

Not that your body
Cannot endure
Dimanche Gras' breathing water
But you prefer dark and cold, salt
Prefer to stay in one place;
Currents riddled with mud
Spat out by rivers:
All that you are
    Until we are glassed again

## WAITING FOR AZAAN

After the afternoon drain streets fill
again with approaching dusk
naan-shops open shutters
date carts grow lighter,
children dash on final errands.
Sun-wizened job-hunters wait still
in wheelbarrows
near low-voiced conferences of sheep,
heads bent as if considering their fate.

A boy already a man
washes his feet in the jooey,
red-faced cop pulls man from car
beating him till he pays,
even on Friday, even
in the holy month.
White beards and clustered listeners settle
in unglamorous parlors—blankets spread
on ground or wooden platforms,
No one is alone.

Millions thirst, waiting for azaan,
hoping to trade comfort for favor,
bowing like broken reeds,
offering hearts full of hunger.
But how many who speak
salaams left and right
rise from prayer-bent knees
with anything but peace
pervading perverse minds?

Don't shackles on wrists
of God-lovers clatter on
in sharpening darkness,
shab-naamahs piled high,
thickening amid book-stacks
bloody with bickering?
That fast is a cobweb
that will not cover shame.

Ancient seers sung
the fragrant fast:
to welcome nomads,
shatter chains
wrap warmth
make peace
heal—
*this* is true rooza.

Shadows pass and greet:
*qabool boshad!*
*Accept, oh God!*
As dawnlight breaks
and night retreats,
spent worshippers begin again
in the belief
(or fervent hope at least)
that this fast will reach
the greatest heart.

One prayer rests
at the inn of noble Name:
*may this hunger*
*carve a door,*
*may it open us to grace.*

Notes:

*Azaan:* call to prayer that signals the day's end and the breaking of the fast
*Jooey:* open gutter, also sewage outlet for nearby homes (Dari)
*Shab-naamah:* night letter (Dari)
*Rooza:* fast (Dari)
*Qabool boshad* literally means "may it be accepted." A traditional Ramazan greeting is "Rooza wa namaazetan qabool boshad," or "May your fasting and prayer be accepted."

# COURAGE

# CHOICE

# CHANGE

she's—

she's lighting a cigarette at the wheel, I guess she smokes now
her little car's zipping and she brakes hard at red lights
she's charged after a fullmoon drum circle by the water
she's singing along with the radio—I was a terra since the public school era
no she wasn't
that time she made her mom stop the car cause she saw a turtle on the road
she brought it to homer, the guy who had turtles for pets
it wasn't one of his but he thanked her like it was
it was a small town back east
back east
people say that like it's the origin of all things—all memories
it's not
there are things out here, too
things that attracted her when she was old enough to choose where she lives
she's living here
making new memories
she's her own person, she says
she really looks like a woman
she smiles deeply, in the eyes too
she does this thing where she's always flipping her hair
or putting it up or letting it fall
like she's got to show you it looks great no matter what
and it does
she tells me she's been checking up on all the boys she thought she loved
turns out no
she's seeing them for what they were
are
and now she gets to move on
to the unknown
I love that shit, she'll tell you
she's blowing smoke out the open window
she's tucking hair behind her ear
her boots got sand all over the back seat but she doesn't care
she's not worried about any of that

At the base of the Mountain
drop your breath into the belly cauldron and begin

## THE HANGED MAN

start with your feet at the base of a tree
and walk up the trunk
hauling yourself upside down
hugging the tree with your body suspended
contracted
and in this way you have surrendered to the mountain

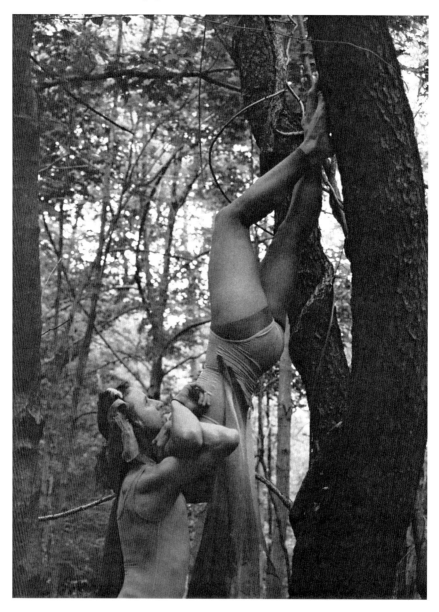

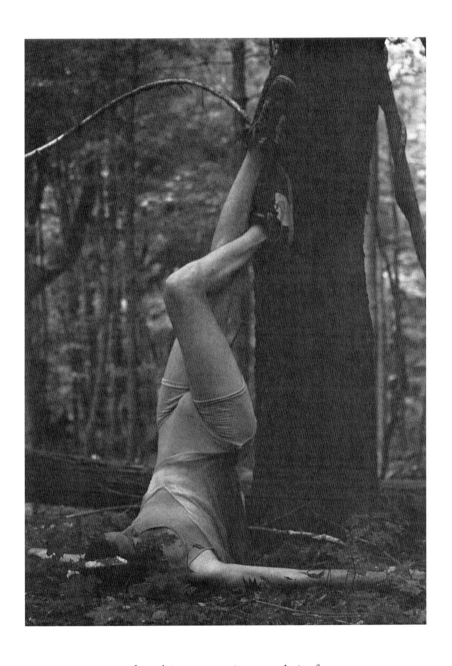

Eliza Swann

and in this way gravity reveals its face
your hair becomes your root
and the spiritual mastery of the upside down
is yours

Rajesh breathes into his scarf for warmth on the way to Rittenhouse. December cold, but he takes pleasure in the walk, the shoppers and pedestrians. Holiday wreaths dot Broad Street with their red bows and white lights. White snowflakes glitter on lampposts, suspended in midair.

Herman is the only other person he knows on the fringe, outside of the business/legal/software swamp. Herman the German, they call him. "Where's the big HG?" "What's Her-Ger up to tonight?"

Herman had gone to high school with Rajesh, one of the few from Summit, New Jersey, to defect West. Stanford had seemed daring at the time, bold and adventurous. Rajesh had felt tethered, as though someone had taken a compass and string when he was born and drawn a circle from New Jersey indicating how far he might stray. Herman might as well have set off with an Indiana Jones fedora.

But Herman had that way about him, always doing the unexpected, too big to be contained. He was one of those people who seemed taller than he was, who fairly boomed around others. And it's not like he'd been a cool kid in high school. But Herman somehow made Mathletes and the school paper and the tennis team less lame.

And while people accepted Rajesh because he was benign, a floating high school amoeba, people liked Herman, delighted in him, because he was so unabashedly himself. He could wear his tennis headband in the halls or tie his hair into a sumo-

like ponytail at the top of his head and, grinning, never catch a word of flak about it. Rajesh's mother had said it best. "That one," she said, eyeing him in his retro orange polyester jacket, "is an original."

He'd been thrilled when Herman landed a job at a video game company in Philly after graduating ("Of course," he'd groaned. "Only you"), his old sidekick returned. And he hadn't been terribly surprised when he got the voicemail a few days ago: "Quitting. Joining a start-up. So pumped. Steak?"

Rajesh pauses on the corner, waiting for the light. Walnut shimmers with its spectacular wash of retail. A new Kiehl's stands on the corner; the Striped Bass gleams with its glass and gold. He makes a mental note to bring his parents this way the next time they visit. His mother was always clutching her purse while his father went on about how Philly real estate was on the decline.

His parents, of course, had hoped he would settle down in New York after Wharton. "Solomon, eh? Maybe Goldman?" Rajesh tried explaining to his dad that he worked in marketing, not finance. His father always nodded absently, the nouns and adjectives floating past him. "But Manhattan would be so much closer," his mother complained.

"Mom, I have friends going to San Francisco," he reminded her. "London!"

"Grace moved to New York," she countered. "Makes so much money! Have you talked to her recently?"

His parents do not understand Alicia. They skirt around her in the apartment like a piece of furniture or a strange pet that must be tolerated. Occasionally they bumped into Grace's parents, who ran a produce market in Summit. "Now they can retire, of course," his mom said, as though their daughter's proximity made this possible.

The only thing they asked Alicia when they visited was how her "practice" was going—as if she were a doctor. "I have some wonderful new clients," Alicia would reply, chipper. "And I still teach my classes at the Y." At this she would throw Rajesh a fond look, reminiscing. His parents would nod, embarrassed, and look away.

But Herman likes her, he thinks, crossing Rittenhouse. When the three of them hang out, grabbing beers at the Nodding Head or strolling through the Italian Market, he doesn't feel defensive about Alicia or like he has to explain her. ("Oh," Sanjay had said, alarmed, when she moved in. "I hadn't realized it was—you know—serious.") He likes that they don't talk about work when they're together, that there is none of the bitching and moaning he gets from his other friends. "Grace billed four hundred hours last month," Andrew had told him, incredulous.

When he is with Herman, he appreciates Alicia anew. He likes that she cares about her clients, that she puts such thought into her classes, experimenting with new routines in their living room. She does not come away from parties hissing that Andrew will never make partner.

He likes that he knows exactly what she does for a living; there is no flutter of anxiety when someone asks. He can picture her clearly at the Chestnut YMCA where they met, where she had first gently righted his shoulders and smiled at him, encouragingly. He can see her teaching a class, balancing on one leg, her long limbs steady. Adjectives and prepositions and adverbs pour forth, clarifying where, why, when. There is no shortage of words, no murky uncertainty to give him pause.

Herman is nowhere to be seen in the lobby of Morton's, so he accepts the offer to be seated. Around him, dinners are in their languorous stages. Men in suits lean back in chairs, savoring spirits that glow various shades of amber. They laugh indulgently, the air around them magnanimous with goodwill. Rajesh wonders if this will be him one day—if he will ever learn to like whiskey, to lean back in his chair without fearing it will tip.

He hears laughter and sees Herman heading over with the waitress. A few heads turn, for there is something of a strut in Herman's walk, something of pomp.

"Dude," Herman says, shaking Rajesh's hand. The bonhomie from the moment with the waitress spreads to the table.

"So I have to tell you about this start-up," he says after they have ordered drinks. "I just signed with them. Did I say that in my voicemail? And it's genius."

Rajesh nods, signaling him to go on, but Herman waits a beat, surveying the room. "Toilets," he says.

"Toilets?" Raj repeats.

"Toilets," he confirms. "Look around this room for a second." He lowers his voice. "How many people here are significantly overweight, do you think? Obese, even?"

"Um, I don't know." In truth, the tables around them are filled with fit middle-aged types, guys who probably had weekly tennis ladders and counted carbs. But Herman does not notice his hesitation.

"Everyone knows this country is getting fatter. It's the new epidemic, right? But we aren't equipped to deal with it."

"So you're making toilets for fat people?"

"Better. You've seen those wall-mounted ones in restrooms? The self-flushing kind? Turns out they start to leak at about 300 lbs. Partly because of faulty installs, actually. And then, you know, there's the added pressure when people lean to one side." Herman demonstrates, holding his cloth napkin to his posterior. "Anyway, we're making add-ons. Supports that increase the weight load and add stability. No leaks. Low-cost, easy to install. A no-brainer for any commercial facility."

"Huh."

"It makes sense to have a product that taps into the demographic. Growing market, so to speak." Herman smiles.

"And this will be here? In Philly, I mean?" Before the question comes out, Rajesh hadn't considered the possibility that his friend might move. His gin and tonic is suddenly heavy in his hand.

"It's out in the burbs, actually. Lower overheads and all that. But I'll keep my place and commute. That's the plan, at least."

Rajesh takes a sip of his drink, unprepared for the level of relief he feels—relief over something he hadn't even realized was a concern. He looks up, realizing that his friend is waiting for his verdict. Not that Herman needs his validation. Everything always felt so settled with him, already in motion, stretching before them like a vista. "It sounds great," he says, because he needs to say something. "Really."

Herman looks across at him and beams.

...

("28" continues on pg. 65)

*Maya Lang / Stacey Toth*

Didn`t I once like alphabet soup?
Didn`t I once think that whatever I ate
Should have the shape of a letter?
Didn`t I once feel that this was the way
To master the elusiveness of words?
Because words felt like slippery things
Worming around in my head
And slithering out of my mouth
However they did
Even before I began stuttering
This was the way I felt
And didn`t I once think
That this was a silly idea
That whatever I ate
Should have the shape of a letter
To master the elusiveness of words?
And didn`t I once think that Hegel was right?
That "the is is the ought?"
And didn`t I once think that "the is is the ought"
Is a stupid and indigestible idea?

And wasn't this why "the is is the ought"
Slithered away into the kind of silence
That swallows a human presence
As if a human presence
Is really a digestible thing?
And wasn't I once unable to speak
For a long time, feeling as if
I had no sense of direction
And I began to write poems
However they slithered around on the page
And read them aloud to the air
To recover the function of speech
In a park, on the street, in a café, or a bar
I read anywhere. And people began to applaud
And today I am asking myself
Aren't these people as crazy as I?

Jack Tricarico

After the caryatid fell from the merkin ball, flashing her eyes by latisse, I rode out with mohawk dyed to black in the manner of memento mori. The cancerous non-thoughts had spread upon the mall-speckled landscape and thru the link catastrophe kept with media reports of Martha Stewart's byzantine code of style. Appareled in the waist coat of irrelevance, which in sepia photos shone with a hint of gold, I disembarked from the galleon of fond remembrance and gave up on you because to prosper with a hospice training program buried in my heart like a straw for the cannibals, whose metaphor I endure, is a way of saying obsolescence, grief: a constant goodbye. So with a long drag on the particulated wind that nets my tongue in another hemisphere's waste, the moon rises as a smudged reflection from the credit card waived in the hand of a gangster's wife. But there's really nothing left to buy or claim for one's self—least of all for our parasitic twins. It's a quiet departure, just the clicking of heels and the sounds of paper wings. The hospital chairs so unbearably white among synthetic sunflowers that I drown in pantomime, holding a mobile phone like an astrolabe to my eyes—like a wish I could map for the restless swallows to return, their pale-throated cries raining down on our destroyed imaginations.

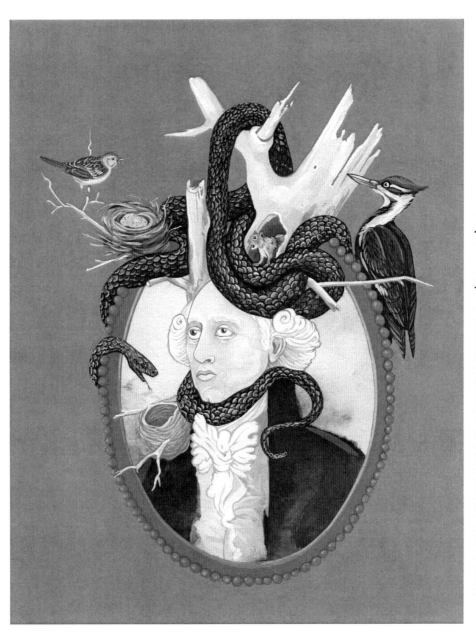

Sir FRANCIS DRAKE BLVD. (II)

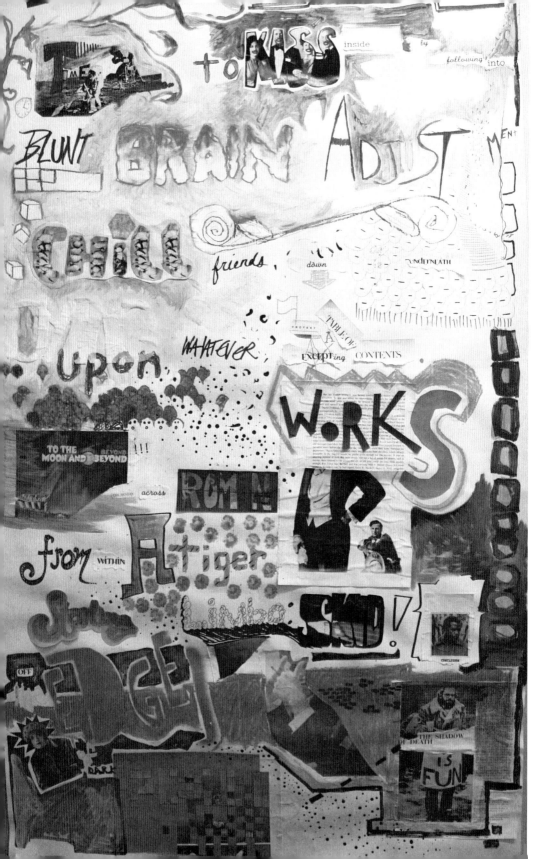

time to kiss inside by following into
blunt brain adjustment. chill, friends,
dawn is on underneath, dying upon
whatever, protesting a table of contents.

to the moon and beyond!!!

the heyday across roman works from within a tiger
starling limbo: SKID! {conclusion}

off the edge of dark pixel necessity!
the shadow of death is fun.

SOLON:

Dirty Demeter plays in the dark tonight.

SHIP OWNER:

Take a rest. You've seen too much sun.

# A<small>CT</small> III

SOLON:

I chase the sun all day.
It leaves with a grand farewell,
then beams way behind me.

SHIP OWNER:

Rest, wait for your
wife—pray for pity.

You dared the gods to strike you
senseless.

They did, you see.
Apollo took your
reason.

SOLON:

The gods need it more than I do.
I live with blood oaths and silence.

He's a healer. Legends don't lie.

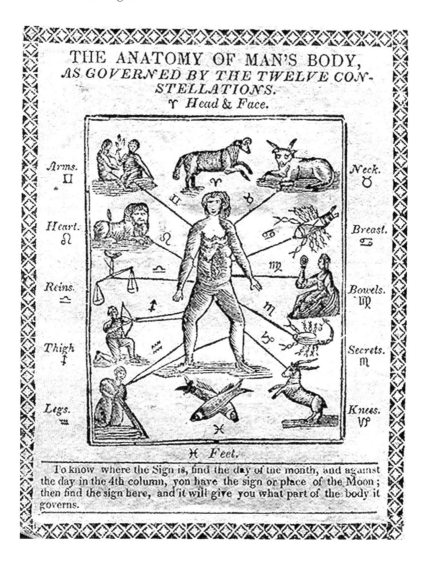

He can straighten the crooked foot and seal the harelip.
Seduce the black from a coal miner's lungs and banish the dust to the air.
Smooth the blistered hand with the words
                              "Blisters, leave that hand."

He's a divining rod. Feels the presence of a copper vein in his bones.

He can trace the map of an infant boy's life by the shape of the head. Knows if the child will grow to be lawyer or killer.

He's the hoochie coochie man's older brother and first cousin to the little red rooster.

<div align="center">

### Conjure Task

</div>

*Write a 12-bar blues, three stanzas long, using the following seven words:*

>Locomotive,
>Longtime,
>Eyes,
>Rain,
>Running,
>Highway,
>Appendectomy.

*You may add the articles "a" and "the" and the preposition "like," but nothing else.*

When you have completed your lyrics, set them to the tune of "Rollin' and Tumblin'." You'll be following in honored footsteps. Robert Johnson and Willie Dixon, respectively, appropriated it for "If I Had Possession Over Judgment Day" and "Down in the Bottom."

At one minute before midnight, sing your blues.

The seventh son of a seventh son will materialize in your home. He'll remain your guest until you write and sing a second blues consisting of the seven assigned words.

## IN GREEN BEGIN

in green begin
blue mourn to night
                              this is Paradise *turquoise*
                     The United Paradise small
small things not large things trouble
*shocking pink* inner blank *gray greige beige. Puce.*

                              which goes toward infinity or
                    shrinks to zero indefinitely spacious platforms
                    colors vivid and lifelike statues if this is if this is
           city of lightbulbs *is this if is this if* canyon *ultraviolet infrared*
                    interferes with the sky *yellow yellow* and *yellow*
                              light interferes with the sky
                                             what is

illuminated?
the *Death or Glory* T-shirt
   a skull   a rose   a patch of green?
does the limit form the picture shall I try it?
out
comes the umbrella rainjacket "scary"
mega doppler 3 pickup cloudy
look lightning Roanoke gusty
Hellertown sun breaks at Jersey
dozens head to silver screen still
reds         gone?
braincase-blue: sky
        Krazy Kat gets whacked with a brick by Ignatz what am I
holding?
Etel Adnan maps to calm her heart buys maps
he who sits by the Bay of Okhotsk
salt-crusted mineral beach of Okhotsk
follows the rusted steamers move out
his sister died of fever
he fetched her snow
his sister died of fever
he fetched her snow
not enough snow
*

*very little room to move now*
        ∧

this is the purple room
  consists of the "shed plane"
    its violent contours

        "you should have slapped him with your beaded handbag"

                            ∧

              make a face. lips pucker up. spit.
              spit muscles weak. dribble out.
              pureed peas. bright orange squash.
                small one. high chair. refusals

              put a face on hurricane. make it go
              down. water. swallow one country.
              gulp under god. liberty justice. gag.
                who for all is. who f.. all .s.

              smears red onto his pursed lips. sleeps
              in the park. raped. "faces it." *fa la face
              contenta*. make the face content. smears
              red on his lips. tries on: raped woman.
                            tries it on.

Phyllis Wat

am holding on, is holding on, are holding on, and spraying and spuming and storming
and tossing and slamming and struggling and not hopeless yet, not think hopeless yet,
just holding keep holding try holding am holding, is holding were holding still holding
still going oh now lifting up, over—*oof!* slamming down—lifting up, over—*oof!*
slamming down—up over now under oh over now under keep holding am holding still
blowing am holding still keeping still pounding still keeping still roaring still cracking
still staying still gripping still keeping still keeping still keeping

# PINK SLIP

faded colors
the drug store's
spring display

Let's face it. I was 1A. Being scheduled for urine samples while muttering I don't even want a job. While the recruiter refuses to look at me I imply outloud that I'm just another commission to him. "Well!" he runs at me with a roar, "you'll get nowhere with that attitude," his disembodied voice a slamming door.

I feel my fear avalanche—when instinct tells you to run, but you can't feel your feet—and my landlord's bleating cries he needs the new Benz this year. A mushrooming mob pursues me through the streets in my ears. How many others need me to get a job? Then I get it. Yep, this is where I sell my Bill of Rights for a paycheck, my native freedom for some kind of dream.

I slide into reverie. Of when I was ten. My favorite aunt, Ann, is buying me my first pair of nylons, Round the Clock, with pale pink slip and garter belt accessories from the sixth floor of G. Fox & Company. I gawk at the saleswoman as she deftly stuffs money into the hollow flank of a stainless steel cylinder, turning its top counterclockwise until the side closes, silently, like espionage; as she balances it upright beneath the lip of a narrow portal until suction snatches it upward into an apparently labyrinthine vacuum-tube system of cylinders rattling by each other in a continuous exchange of energy and currency.

O, Houdini, show me that false wall between company and country. Slip me through this packaging, of me. For I have fallen through the safety net spell of belief in this marketplace of trickology. Please help, help us all, Harry.

the thinning trees . . .
another side
shows through

MEANINGFUL **OBJECT** DISPOSAL INITIATIVE 24010

| INTAKE FORM | All personal information will remain confidential. It is necessary only for the legal transfer of the object's ownership to the MODI. |

Name: _____

Address: _____

Tel: _____ Email: _____

Description of Object: _____

Are you the legal owner of this object?   Yes ☐   No ☐

Is this object connected to any current, pending or possible legal action?   Yes ☐   No ☐

Please choose one:

☐ I would like my object to be destroyed

☐ I woud like my object to be relocated and distributed to those in need

☐ I would like the MODI to decide

May we display your object in public? Only the object and its story will be displayed; no names or identifying information will be used.   Yes ☐   No ☐

I hereby certify that the above information is true to the best of my knowledge.

Signature: _____   Date: _____

FOR INTERNAL USE ONLY

I.O. # _____   REC: __/__/__   RFP: __/__/__

Disclaimer: The MODI is not a government-sanctioned social service organization. It is an art project offering help. © BECS 2010

**24010**

RECEIPT OF SERVICE   **24010**

The MODI acknowledges receipt of your object. Your participation transfers legal ownership of this object to the MODI. Please direct any questions to:

MODI c/o BECS
P.O. Box 931
NY NY 10002

MEANINGFUL **OBJECT** DISPOSAL INITIATIVE

Donna Fleischer / MODI - Sara Shaoul

## EUROPA (*excerpt*)

Ferenc never liked going over to the Kőbánya-Kispet junction, with all its bums, criminals and other assorted losers milling about, selling junk on the street, lingering in doorways, looking for handouts. A regular "bum bazaar," Istvan had dubbed it.

However, this is where Dagomir lived, István's Bosnian friend who came to Budapest at the start of the war that tore his country apart. Ferenc was never thrilled with Dagomir. He thought him strange and dangerous, but he was the only person they knew that had what they needed.

Ferenc and Istvan approached a dilapidated old building with two drunks sleeping in front of the doorway. They ignored them, rang Dagomir's buzzer, not even knowing if the thing still worked. It looked as if someone had tried to pry it off the door jam.

"Look at these two," István said, nudging the sleeping bums with his foot. "Another inch closer he'd be sucking his dick."

"Perhaps he was," Ferenc laughed.

István pressed the buzzer again. Then a groggy voice between squeaks and pops came over the intercom.

"Dagomir, it's István. Let us up."

"Who?"

"Come on you, ass. It's István. Ferenc is with me. Let us up already. It stinks to high heaven down here." It took another couple of minutes before the door buzzed open.

They stepped over the sleeping bums and made their way inside to the ancient elevator.

"I always hated this thing," István said. "I bet you the cables haven't been changed in over a hundred years."

"Let's take the stairs then."

István pressed the button and listened to the clunking, squeaking, grinding noises.

"Perhaps you're right," he said.

The stairs didn't seem to be any better; the rotted, gnarled wood felt as if it would break under the weight of their feet. They took their time, testing most steps before putting their full weight on them.

"Is this building condemned?" Ferenc asked.

István shrugged.

They were winded by the time they reached Dagomir's fourth floor apartment. After catching their breath they approached the door. Where the peephole once was, an open hole now allowed anyone to look directly into the apartment.

István looked in and saw the mess of magazines, newspapers, empty food cartons, cigarette butts, and loose papers scattered across the old wooden floor, which sloped

Julian Gallo / Max M. Leon

toward the back of the building to such an extent that two worn-out paperbacks had been used to prop up the night table.

He knocked on the door, listened to Dagomir grumble as he shuffled across the floor, kicking debris out of his way.

Dagomir came to the door looking like death himself. Pale, emaciated, his hair matted into little dreadlocks, a few day's growth on his face and big smile, his grey teeth just shy of falling out of his head. He stank terribly. There was no way to guess how long it had been since he had taken a shower.

István was stunned by his friend's appearance. It had only been a couple of weeks since he last saw him. What the hell was he doing with himself?

"István. Ferenc," he said, stepping aside to let them in.

Ferenc immediately smelled vomit and instinctively covered his nose and mouth with his hand, let his eyes scan the filthy room. There it was, a fresh pile, splattered on the floor, fanning out in little tendrils near the lone, stain-covered mattress that Dagomir called a bed.

"Have a seat," Dagomir said, waving to nothing in particular.

"Goddamn it, Dagomir," István said. "You have room spray or something?"

Dagomir looked at him. "I'll see. I doubt it, though."

István watched his friend rummage through a cardboard box filled with various items that he evidently bought from the street denizens outside his apartment building: taped up extension chords, various light bulbs, worn out shoes of varying size, a ball of twine, but unfortunately no room spray.

When he first met the Bosnian refugee, he always sensed that he was a little off. The war did that to him, that much he understood, but physically, he was robust. It pained him to look at him now. A virtual corpse.

Ferenc looked around the large loft-like studio, convinced that it had never been cleaned. Ever. A junkie pad. No more, no less. The stove was caked in grease and other unidentifiable bits of grime, the refrigerator was not plugged in, and the couch was covered in cigarette burn holes, the cushions stuffing all but gone.

He wondered how long he had been squatting there. There was no way in hell he was paying rent on this place. Then he peered into the bathroom.

*No, it couldn't be*, he thought, but there it was as clear as day: a hard, dried up turd about four inches in length, right in the middle of the bathroom floor with an army of roaches feeding on it.

He ran out into the hallway, leaned over the banister and vomited.

Julian Gallo / Max M. Leon

"Hey, are you all right, man?" István asked, poking his head out the door. Ferenc looked at him, wiping his mouth with the back of his hand. He didn't have to say anything.

"We'll just get the shit and get the fuck out of here, all right? You don't even have to come back in. Wait there, I'll be right out."

Ferenc leaned against the banister and tried to get some fresh air, if that was even possible. He always knew that Dagomir was fucked up. He just never realized how much.

After a little while István re-emerged from the apartment, bringing the vile air out into the hallway with him. Ferenc gagged but managed to hold it in, started immediately down the stairs.

István called out to him, taking the steps carefully as he tried to catch up. Ferenc paid no mind to the rickety steps. He just wanted out of there.

When he reached the door, he nearly tripped over the sleeping bums, then looked up to the sky and cursed. He turned to see István carefully and casually stepping over the homeless men and held his hands out.

"What's wrong with you?"

"Sorry, I had to get the fuck out of there. I mean..."

István laughed.

"Yeah, he's vile, isn't he? He's had a rough one, though. He's damaged from the war. Saw a lot of terrible things, you know?"

Ferenc wanted to say something but decided against it. Yes, the war was fucked up. He knew that. He'd met others from the Balkans who went through hell back then but not one of them ever shit right on the bathroom floor and left it there for roach food.

István cupped the small plastic bag in his hand.

"That's a hell of a lot," Ferenc said.

István shrugged. "The asshole has no idea how much he doles out. We got triple our money's worth. Which reminds me..."

Ferenc reached into his pocket and handed over his share.

"So, your place or mine?" István asked.

"Better make it yours," Ferenc said. "Just in case Bianka decides to pop in. I don't want her to see me doing this shit."

István shook his head. "You got it bad, my friend."

They took the tram out of the neighborhood, leaving its squalor and damaged goods behind. Ferenc leaned his head against the window. It felt cold against his forehead.

The snow continued to fall, a pristine blanket of white that helped take the image of Dagomir's apartment out of his mind.

Julian Gallo / Max M. Leon

## EGO-DOLL DANCE

Make a doll out of twigs, leaves, and mud.
This doll is your ego.
Slow dance with your ego doll
put your tongue in its ear
rub it accross your nipples
memorize its scent
blow on its face
stroke its belly and thighs
carefully paint its fingernails.
Tell the doll about a bad thing you did last week and ask for its forgiveness.
Clasp the doll to your chest and rock it.
Call it "Baby", then "Mama", then "Daddy"
then "Me!" "Mine!".
Applaud for it and clap for it
shout "Bravo!"
and "Well Done!".
Suck on its toes
flutter your eyelashes over its forehead
notice the precise taste in your mouth right now
as you pick a flower
and rub it accross the Ego Doll's lips.
Then leave it to rot on the mountain.

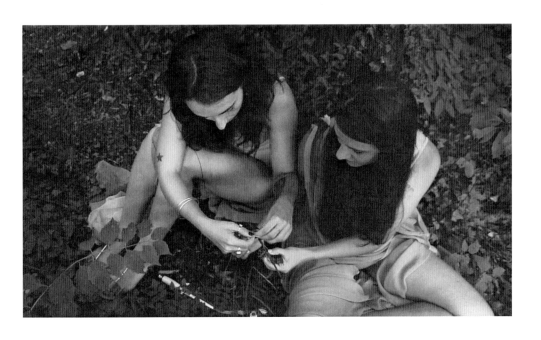

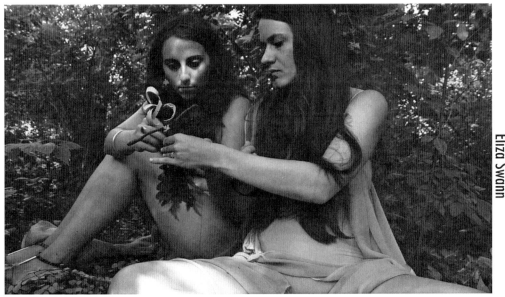

Eliza Swann

The next morning at work, riding the medium wave of his third cup, clicking his mouse idly, Rajesh tries to imagine calling his parents and announcing that he'd quit his job. Tries to imagine the pause on the other end—interminable—while his parents exchanged worried looks, each holding a separate cordless receiver. "Toilets?" they would mouth to one another, stricken.

Yet somehow, if they had been there at dinner, if they had heard Herman's exultant pitch, if they had gotten a glimpse of that panoramic spread while bathed in the cocoon of Morton's, they would have walked away and mused, "That Herman! Always thinking ahead." They would shoot Rajesh a look, wondering why their son couldn't be more of a visionary.

He wouldn't be surprised if Herman made it into *Wired* one day, if there were a shot of him with his wide grin and square stance. The article would laud his entrepreneurial eccentricity. "Thinking Big," the headline would read.

Rajesh clicks his browser window closed, an engineering forum discussing exactly the problem Herman had outlined.

"And how's your job going?" Herman had asked him last night, signaling for the bill.

"Great," Rajesh had replied, his upbeat tone surprising him. In truth, he'd been planning to tell Herman about his new five-cup ritual. He would have introduced the subject lightly. "There's, like, a total linear correlation," he'd say. He'd draw the graph on a cocktail napkin, "Coffee" on one axis, "Cares about job" on the other. The graph would have been a diagonal line, shooting off into space. "Well that's no good," Herman would have replied thoughtfully. But when the moment came, Rajesh felt unable to do it. Another time, he told himself, a smile fixed on his face.

He didn't want to ruin Herman's ebullient mood. And he didn't want to speak the words at Morton's that, like clanging cutlery, might break the moment, disrupt the atmosphere. It was so much easier to go along with what was already in motion. That was what the room had whispered to him with its ambient light and oversized menus, its white tablecloths and obsequious waiters.

He isn't like Herman, he thinks, fiddling with his coffee mug. Not like Alicia. Their bright-eyed happiness involved clipping a string that would send him reeling out into space. Without that tether he would feel unmoored, aimless.

No, he thinks. He admires Herman but does not envy him. For he knows if he were in Herman's place, he would dread being asked about his new job—no matter that

he had found a problem in need of a solution, that there was a certain thrill in saying "start up." He would dread uttering the word "toilet," would detest seeing the smirks of judgment. "Huh," Andrew and Sanjay would say, carefully trading looks. He would miss the anonymity of the fluffy white cloud, even if he had to caffeinate himself to feel its comforts. Even if those comforts sometimes felt thin.

Rajesh thinks of the tangerine timepiece from Hermès. It had seemed an absurdity when Alicia pointed it out, unattainable. But he wonders if it is a possibility, just within reach. (Grace, he knows, had just gotten her bonus at Wescott. "Thirty," she had said, casually on the phone. "*Thousand?*" he'd asked. Grace laughed.) It dawns on him that he, too, will be getting an end-of-year bonus. Nothing so large, surely, but perhaps enough.

He imagines Alicia's hand on a client's back, the gold face catching the light. He imagines her doing a headstand, the thick orange loop of it grounding her wrist.

It is enough, Rajesh thinks to himself, glancing into his empty mug. *It is more than enough, really.* He is at a boutique firm and not a corporate monstrosity. He has the weekend farmers' markets with Alicia, Sunday afternoons stretched on the couch together. Beers with Herman, watching Federer and Nadal, the quiet camaraderie with his old friend.

I'm not drowning, he thinks, standing. He reaches for his mug. Another cup, and he will feel buoyant, lightened. He imagines Grace coming home to her studio apartment in New York ("junior one-bedroom," she would correct) at two in the morning, exhausted, snappish. He imagines Andrew and Sanjay trying to dogpaddle at her depth, the waters dark and deep.

He wasn't free, exactly, not in the way of Herman and Alicia, but he felt the slack in the rope, the give had created for himself. And wasn't that bit of space everything? Wasn't that bit of room more than he had hoped for?

He nods in response to his own question as he walks by the receptionist, who barely glances up. She is accustomed to—no longer puzzled by—his numerous trips, he realizes. He nods, knowing she sees his secrets, his ways of getting by. He nods her way and braves a smile.

3.

arms wide-spread and
grateful...
surfing cement in the dark
    stoned and bumping on rocks
        skidding sliding vertical colliding
          sandal shooting body rolling
            bloodtaste asphyxiation
        soul at the edge of face barrier
        limping organs rearranging to fit
          together
        again

1.

flashfloods interspersed with draught
white needles no thread
an acquaintance's acquaintance
flyers emails LISTEN have you seen this person?
    the question mark void
    the waiting
    the hoping
    the trusting
        the body found in the pond
William Shakespeare never wrote silence
an unknown mirror
never seen somehow similar
cracked and I
remain

A.
    a spirit on a shoulder
    I'm not really here
    conversation shifter
    seeds and walls angle the flow
    mind plant thought growth
    there is no poem
    there is no reader
    heart placed in an unmarked box
    delivered to a stranger
    wondering why I feel
    lighter

2.

bowling ball buoyancy
smiling tentacle tendrils tracing
your face if you let it
you can like it
the power went out
we drove under snow tunnels composed of bending trees
so slowly
there is no speed limit when
the power goes out
the power
went out
model comfort
the too soon reunion
dispersion flags wave
calling recalling
meandering stillness
antiquated truths crack bells
adjustments to recognize teeth
between skin and importance
aren't we
playing a field day picnic game
in high heels and ties these
hallways rearrange chronology
splicing memory with awareness of
systematic narrative native to
uniqueness

B.

my best friends have come
disguised as guardian angels
they will take me to meet the other shore
while humans play the planets
how they fly over earth and rivers
like the winged creatures I sense them to be

C.
    All Hallowed wet cemetery grass
    living through storied corpses
    it is only through death can we understand life
    the witching hour which our private persons

no reason than a barren wasteland
perfect for wasting
too much knowledge
too many ideas
unplanned plans
one woken shoken
infinite prismic vision
already tried

permeate with
incomparable powers of empathic perception
intuitive essences shine through silent senses
this familiar figure unfamiliar speaking from
somehow somewhere even more familiar
like some one I knew in dream suddenly
adopting the shape of companion
on a green corner no one is passing by

assurance
rewired fly higher
simply cause we can.

I've never seen my face
just a programmed image
reflected on certain surfaces
am I really alive?
is this the same life I've been living
within these many memories?
snow falls on whispered tears
an apparition of a person
I've asked to see
me

D.

dance hall free fall
mind body through wall
chat with the devil
incarnate for nearness' sake
tempt membrane holding
allowance through the
agreed-upon-laws-of-physicality
the world hears our thoughts
something BIG does happen
perceptions sway along with
amplified congregations with
the unheard conversation with
the unspoken meaning
scent of stale gold
waiting

§.
desert trees follow
hilltop tai-chi
distance recedes
offroad trail beach
reach highway bush
syringe fruit falling from
electric bird palm trees
acknowledging
this is a crossroads
I am lost
freeing expectations
space for blind enjoyment
a line of kangaroos passing
through an open field from
one dimension to another
oldest to youngest
this is the way of the world
this is the way of the world
this is the way of the world
you can be alone in love

E.

the upstate new york winter soldier
caged in a car eyes closed how far
reading veiled writings
writing on the veil itself
stop the motion
for pancakes; what?

Daniel Aaron

68

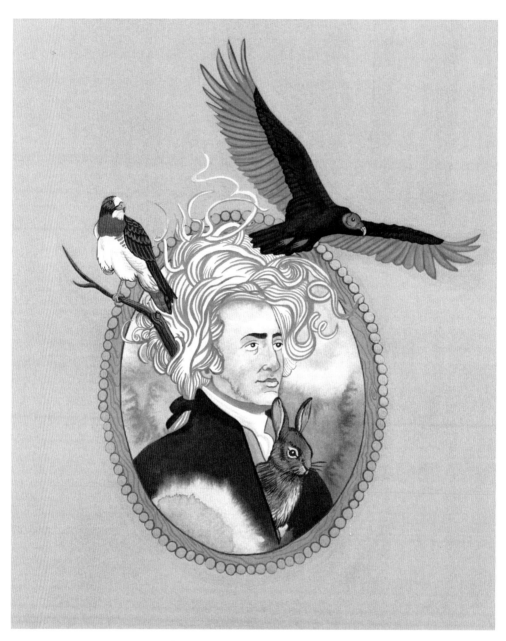

**Sir FRANCIS DRAKE BLVD.**

Do me a solid, sir, in this epoch of rhizomatic dream: set the ice-eyed citizens loose from the suffocating fog of misconceptions, as in towns along the coast and on the bayside they learn to breathe anxiety behind plaster masks of new faith, their children dozing off beyond the crests of anger. I came to consciousness with my palm tied to a hot stove coil. Barely liberated, I still hear the boss of all my day jobs hauling up the stairs to break my balls again. Like an angel that appears with disorienting eyes, I need to meet that fate in a posture of emotional ecstasy, as if to telepathically resuscitate the aquatic life strangled in the estuaries by the chemical rain. Isn't this how we are drawn to and away from what we most desire, beyond endless horizons, frozen in majestic black seas or burnt at the stake down to the metal caps of our teeth? Your name, emptied of its referent that is you, beckons in the back of deluded minds, of which mine is one. For I am a phoneme in the gargantuan syntax of this territory and a coward to the agony it inflicts. But like the glorious sails of your ships that embarked from a spiritual hell, I fasten a demesne to this breakable world of vehicular lights that crisscross in trance like the tides.

concerning a
lost vending machine:
is it beauty?
around
&
outside
by
&
by
excluding...
it's
inside
we cut round

the
the
the

mouth,
taper towards
the anti-opposite
all ends ablaze
without answers

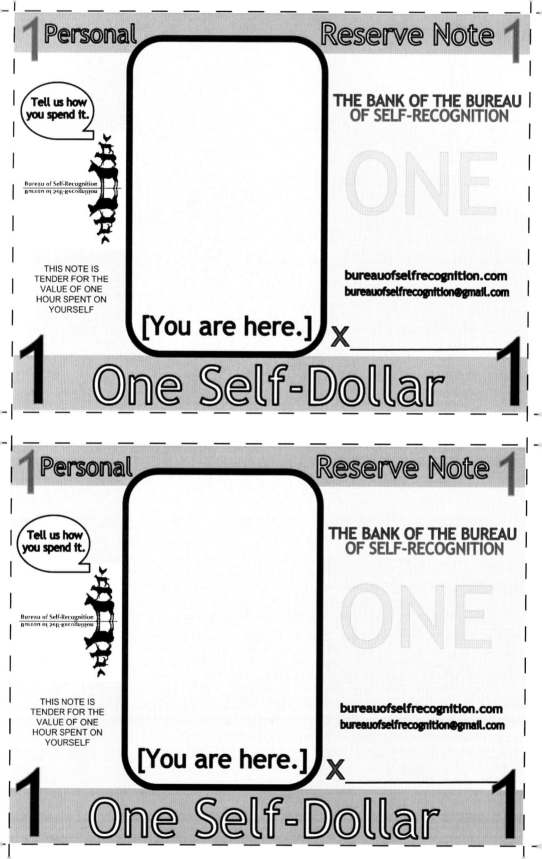

# [APPENDIX]

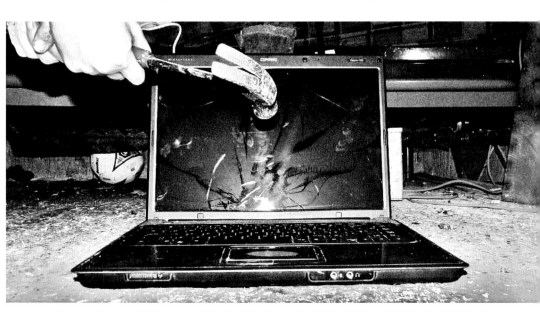

# TABLE OF CONTENTS

## Act Three

*Appendix Cover Photo: Eleven Seventeen - Eleanor Bennett
* Table of Contents Photo: Photogram - Harmon McAllister

# MANIFESTO

Exit Strata was born out of our desire to produce an art/lit magazine—one that's a Post-Modern take on the traditional literary magazine, presented like a revolving-door gallery on the page. Exit Strata is absurd, necessarily, and predicated on harmonious tension: we strive for a 50/50 split between art and literature, often merging the two through collaboration between artists and writers, all playing with the left/right, two-page spread of books (both vertically in the juxtaposition of two pages, and horizontally across the fold) and what can only be done with a book in its hard-copy print form, reinvented between the margins.

But to understand Exit Strata as merely a magazine would hurt its feelings. Exit Strata is a strategy, a process, a community, a creative approach to living life and leaving a trail behind you. Any publications associated with Exit Strata (or its varied eXsT sTraTum) are most accurately described as documentation; of an archive of the production of eXsT that can be replicated in two dimensions. But the sTraTa could never be confined to two dimensions, nor to the timespace limitations of the page; quietly growing in a chrysalis of 0's and 1's, and presented on the inter-web playground (exitstrata.com) which will provide a constant stream of exclusive online content from creators from all disciplines (and those who defy and create new fields), as well as in depth profiles of the creators who make up our global community, across a wide range of disciplines.

The print publication you hold in your hands is envisioned as an artifact, and merely a fraction of our work—which is primarily that of a network of writers, artists, filmmakers, musicians, and other awesome creators. The Exit Strata network is a community of forward thinking, driven individuals and organizations who are changing the creative landscape by their dedication to practice—and to each other. We seek to accelerate the New Way, by creating a place where creativity, too, thrives in and strives for cooperation: leaving behind the Old Way, releasing ourselves from the unhealthy environment of competition and distrust that pervades and poisons our industries.

We are here for mutual appreciation and promotion, with the full and intentional understanding that Network is the new power structure: it is via our Network, and our adjacent, connect-ed Networks already at play on both the virtual/global and local/physical level that we will actualize a new type of life for ourselves, one that places value where we place value. In the world of Exit Strata, creative energy, commitment, and engagement are currency. And you, my friend, are rich beyond measure.

What we're looking for is demonstration of commitment to the work, together—work that challenges, explores, and commits to growth. Work that will inspire us to be better, work harder, and play together. If you are an artist, writer, audio, filmic, or other performer/creator/polymath who feels they would best be suited for our print or web content or otherwise wishes to contact our staff, you can do so at editors@exitstrata.com.

ONWARD! We're excited you're here!

- ExSt Exquisite Editorial Corps -

# EVOLUTION AND ADAPTATION: a RECIPE for CREATIVE RESILIENCE

This summer, as we prepared for our first major fundraising effort, we found ourselves in the position to (re)define ourselves in order to tell a wider audience who exactly we were, and what exactly we were/are doing here at Exit Strata. As any aspiring entrepreneur will tell you, figuring out your "elevator pitch" is an essential step in transitioning from scrappy start up to functioning, funded organization. So we turned the question we kept getting on ourselves: What is Exit Strata?

And the short answer, as perhaps you already know, is this:

Exit Strata is an international creators community based in New York City. We publish a hybrid literary and arts print journal and maintain a robust online blogazine, focused on empowering creative agency across disciplinary boundaries.

But the wizard behind the curtain story is a lot.... messier. The fact is, what Exit Strata "is" keeps changing, in response to what the community we serve needs and lacks—creatively, personally, professionally, and organizationally.

In response, we have had to learn to adapt and evolve: to learn to become resilient for the ultimate good of this community, even when this has meant changing our initial "plans," schedules, and vision. As a result, our organization has had to grow both faster (and slower) than we could have imagined.

The vision of Exit Strata, as the story goes, "grew out of our desire to create a print magazine" that challenged not only the print artifact, but also broke down disciplinary boundaries and encouraged collaborators across a range of mediums: yes, and it was via this intention and promise to ourselves that it soon became clear that our network of creators would be best served by an online platform for this cross-pollination.

And once that platform got established, the conversations and collaborations and series that grew out of our genuine desire to serve creative people—to provide not only a space of publication and promotion but even moreso of dialogue, value-generation, modelling, and resource sharing—took on a life of their own. As one of our editorials reads, "from the seemingly random, the rhizome emerges," and nothing could be truer.

We have allowed our little organism to grow and shift in response to its environment, both human and natural (we recently had to push back the date of this issue significantly as a result of Hurricane Sandy, for instance) but what we've realized across the board is that it is this allowing that is making us strong. Instead of punishing ourselves for unexpected setbacks we are learning from every hurdle—and benefitting, too.

For instance—we are able, as a result of that delay, to give humble thanks here to the seventy-six funders who so generously gave to our indiegogo campaign, to put out this

issue, offer a chapbook workshop, and send ourselves to AWP in the spring with the funds raised in such a short time.

Sometimes we feel like the little engine that could, impossibly attempting feats at a scale that we should leave to more established organizations and publications—but like our friend Buckminster Fuller said, "You never change things by fighting the existing reality. To change something, [you] build a new model that makes the existing model obsolete." And the fact is, we are unsatisfied with our reality, and so are most creative people we know.

And as it turns out, the little light we're holding above our heads like a beacon is starting to make a serious impact. Offering practical resources, models of success stories, and first hand process notes from a wide range of international creators is making a difference in so many lives—we are delighted by the unsolicited work, personal letters, and inquiries about involvement we receive from all over the world.

As a mighty for instance: it has been an incredible honor to become, in the last few months, a mouthpiece for the global organizers involved in the 100,000 Poets (and musicians) for Change movement. In this series we not only archive and document the passionate work of creative people at this unprecedented scale, but also connect and inspire our community to get involved.

Ultimately, every piece we publish online is not an endpoint but a conduit for change on some level, be it personal, community, or societal. Because the fact is, we are not here to hear ourselves talk, or even "just" to publish and celebrate the creative outpouring of the people that inspire us daily. We believe that poets, artists, musicians—anyone and everyone involved in mindful creative practice—is as we say, an "awesome creator," creating not "only" art but the language that aligns all humans, and thereby has the highest potential to make the old model obsolete: to remind us we are more alike than different, and help us create new networks by which we can break the strictures so delimiting our possibilities.

Whether you already define yourself as a creative person or not, there is something here for you. And we strive to be of service at no cost to our collaborators—because we know, as writers and artists ourselves, just how hard this work is. That's why we want to support you in every way we can, and to show you how all of us can implement the technological tools never before available to sustain and empower a new creative age.

As we like to say, Exit Strata is a verb: evolve your expectations!
LEVEL UP.

- Lynne DeSilva-Johnson

< *Exit Strata is a Verb :: Creativity as Lifehack*

*Awesome Creators :: 100,000 Poets for Change* >

# CONTRIBUTORS

In the morning, there is day. Violin strings outside the tunnel door rise hybrid wash lofts, overlooking collared Trappist Trapeze Artists swinging between the urban festinians: the pigeons, squirrels, and business-clad humans. Somewhere in there, between the deer and the trees, the street-sweeping 'chine, and the imported stones of the library steps, is the poet **Daniel Aaron.**

**Joel Allegretti** lives in Fort Lee, NJ, and once upon a time taught taekwon-do and played guitar on stage with Pete Seeger, though not simultaneously.

An avid practitioner of the everyday, **Chloë Bass** has recently relocated from the chaotic, beautiful city where she was born to a castle in the woods of Germany.

According to reports, **Andre Bagoo** is a poet and journalist from Trinidad and Tobago.

**Amy Beecher** doesn't always buy organic but she volunteered after Sandy. *www.amybeecher.com*

**Eleanor Leonne Bennett** is an exhausted person on fast forward slowly figuring out pointlessness.

**Marissa Bluestone** is an investigator of fissures buried deep beneath the soil in her native New Jersey. Her large scale project is to get all the continents back together. She rooms in Queens with the entire roster of the New York Mets. *www.marissabluestone.com*

**Lauren Marie Cappello** remains preserved in a mason jar on a shelf in New Orleans, Louisiana.

**William Considine** feels so fortunate to live within an internal song of joy, in NYC and at *www.williamconsidine.com*.

A Hartford CT native, **Donna Fleischer** writes-walks tightrope from manmade urban streets to the great flood plain roads, paths, and ridges of a traprock mountain.

**Julian Gallo** lives in New York City and is often buried under piles of books, CDs and paper, occasionally coming up for air to enjoy this thing we call life. *www.juliangallo66.blogspot.com*

**Maya Lang** lives in Seattle, but not in a houseboat, nor clad in fleece, and is only very occasionally sleepless.

**Daniel L'Homme** is the man.

**Farzana Marie** is a seething cauldron of passion whose ivory comb was stolen from her yurt by the madman she now pursues on horseback.

# CONTRIBUTORS

**Linda L. Lambertson** is a vagrant love child of the Tri-State Area who knows that when you stare into the abyss it ignores you completely.

**Max M. Leon** is the first carbon life form with a dual silicon chip neural-net processor to win the prestigious "9th Parallel Pseudo-Metabolic Simulacrum Award" for excellence in cybernetic assimilation.

**Carey Maxon** resides in Brooklyn, making dots for herself and others. She is responsible for our beautiful cover. *www.careymaxon.com*

**Harmon McAllister** lives in Westchester, NY where he spends most of his time completing the requirements for his curmudgeon merit badge.

**Dan Owen** is a small aquatic mammal in Brooklyn, NY.

**Jacob Perkins** spends time in his East Williamsburg studio carving lenses out of glacial ice to observe and alter the future of tasteful pornography

**Justin Richel** can be found subversively taunting the culture of consumption, hugging trees, hoarding stones and digging holes in the mountains of Rangeley, ME.

**Legacy Russell** has set up a giant neon Slip n' Slide that goes between New York and London. She likes to cover herself with glitter, turn up music really loud, and roll around on the floor.

**Sara Shaoul** is a Brooklyn-based artist who spends about 75% of her day thinking about time travel.

**Peter Jay Shippy** is a motion-capture studio model whose ominous acrobatics create tildes for Spanish poetry videos. *www.peterjayshippy.com*

**Gary Sloboda** is waiting for the bus in San Francisco.

**Eliza Swann** is an interdisciplinary artist and tarot healer based in London and New York—her choreography puts its foot into the mouth of the circular serpent.

**Stacey Toth** was born on a Vegas desert, under a sun that melted ink into her nails as a leave behind.

**Jack Tricarico** always develops a sensation of indefinitely receding whenever anyone asks where he's from, which at present is the East Village in Manhattan, NYC.

**Phyllis Wat** trundles the Flyffya-Nyorque warps triturating absolute ideas even that one.

**D.A. Wright** is a fictionist who should not be trusted with industrial machinery. He spends long hours in the dark thinking about the collective unconscious and is prone to tirades on the great accident of humanity. He is the author of *Arbitrary Nonsense* and is currently working on his second novel *The Last Days of Lawrence X. Polk*.

**Lynne DeSilva-Johnson** prefers to be described in the universal language we've only begun to (re-)learn. In lay English she can be called Poet, Educator, Friend, Philosopher, Alchemist, Artist, Writer, Healer, Conduit, Rogue, Free Spirit, Instigator and occasionally Curmudgeon. Her students think she is Eccentric, and she likes that very much indeed. She can be found at The Trouble with Bartleby (*www.thetroublewithbartleby.net*), via @onlywhatican, and lurking in the cobwebbed corners of the mental universe.

**Benjamin Wiessner** appreciates a well placed em dash. He still listens to that song by Petey Pablo and he believes in the untapped culinary power of country ham. He values sensible footwear. He always keeps a tent in his trunk. He was raised to witness the emancipatory power of storytelling. These are all source texts for his aesthetics. He is also part of the film collective ornana, their work can be found at *ornana.com*.

Exit Strata: Print!
Volume No. 2
Copyight 2012

PRINT! Vol. 2 has been set
in Myriad Pro, LTC Kennerley, Futura
and printed at Spencer Printing, Honesdale PA

Exit Strata is published twice annually
Submissions accepted year-round

Please explore our creative community online at:
www.exitstrata.com

For more information about the genesis of PRINT! Vol. 2,
contributor interviews and multimedia content, please visit

www.exitstrata.com/print/two

This issue of Exit Strata wss made possible
by the support of our friends near and far
and enabled by the fiscal sponsorship of
Fractured Atlas
www.fracturedatlas.org

please consider a tax-deductible donation
http://bit.ly/exitstrata_fracturedatlas